My Style

My drawing style mainly consists of a huge variety of patterns, shapes, lines, and dots, all mixed together to create intricate compositions with a high visual variation. It has elements of multiple art styles, like dotwork, black and white linework, Zentangle® art, medieval ornament, etc. It is heavily influenced by nature—my all-time favorite subject is animals. When it comes to coloring, although I'm not a professional colorist, I always choose an approach that guarantees a certain precision, and I love making my designs look three-dimensional and shiny, as if they're made of metallic elements.

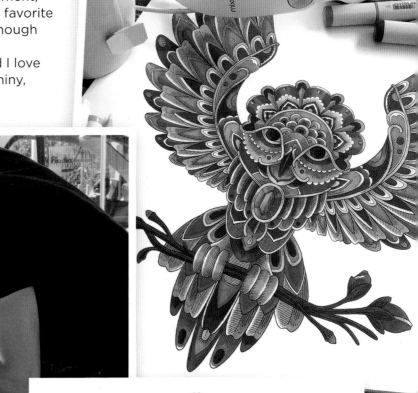

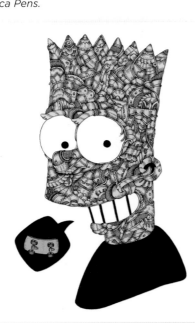

In summer 2015, the Smart car company asked me to customize the new Smart ForTwo for an event in Alghero, Sardinia. I painted every inch of the car except for the glass and the wheels with Posca Pens.

This is part of my "Simpson Family" series, a personal work from early 2015. I was experimenting with portraits done in my decorative style. The inking part is all freehand—I didn't draw it in pencil first.

This lion from 2014 is one of the first pieces I did in my ornate style, and possibly the most successful one. It's probably my favorite work to this day.

Coloring Tools

As you may know, there are tons of different coloring tools and mediums out there, each one with its own characteristics. There's not a right or a wrong one to use; you just have to find the one that suits your coloring style best. I personally try to use as much variety of art supplies as possible; I love experimenting, and I feel like changing your medium from time to time keeps your art unique and intriguing. Here are a few examples of art tools that I like, along with some of their pros and cons.

Alcohol-Based Markers: These kinds of markers are excellent when it comes to blending colors together and creating nice, smooth gradients. Since my coloring style has the goal of making the design look 3-D, I use alcohol-based markets frequently. They can be a little expensive at times, and they do bleed through thin paper, but they're definitely amazing art supplies.

Water-Based Markers: Run-of-the-mill, inexpensive markers are water-based instead of alcohol-based. For this reason, they usually don't layer on top of each other or blend very well. They're pretty useful for flat and basic coloring, and may be a good starting point for a beginner, but I personally don't use them very much!

Colored Pencils: If you're not a big fan of markers, colored pencils are probably the best alternative you have. They come in a ridiculous number of different colors and values, they're usually less expensive than alcohol-based markers, and you'll be able to blend them together nicely. They also don't bleed through paper, but they can scratch it if you apply too much pressure when using them. Overall, they're great for coloring and highly recommended by both professional artists and amateurs.

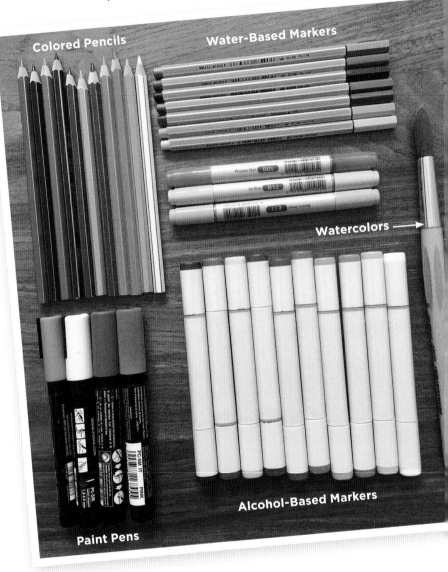

Paint Pens: Paint pens use an oil-based paint, and generally require shaking before use. Their coolest feature is that they can overlay all other colors and mediums beneath them, making them perfect for patterning and detailing. Just imagine adding lines and shapes with a white paint pen to an already dry, layered gradient! They are sometimes quite expensive, but definitely worth a try. Gel pens (not pictured) are a tamer, less expensive version of paint pens that also layer on top of other colors, and are definitely worth a try.

Watercolors: Probably my least favorite medium (solely because I'm terrible at using them!), watercolors generally require a higher level of ability to execute well. On the other hand, watercolors can create some great effects: you can layer and blend them and create light and shadow areas, and they give your piece great texture. You can find inexpensive watercolors, but if you're looking for the more prestigious quality brands, you'll have to invest some money. Or you can try using watercolor pencils, which are a way to create a watercolor effect without the need for high level painting ability.

Picking Your Color Palette

Many people say they have trouble knowing where to start with a coloring page, especially when it comes to coloring big, heavily-detailed designs. The smartest thing to do is to start with a simple decision. One concrete decision you can make is choosing your color palette: all the colors you're going to use for a certain illustration. Here are a few golden rules for picking color palettes that will make them look amazing.

Don't pick randomly. Generally speaking, choosing colors with a logic helps keep the drawing coherent and avoids unnecessary visual mess. But if one day you just feel like being adventurous, go ahead and do it! Your ultimate goal should be to have fun.

Give a "temperature" to your drawing. That might sound weird at first, but it essentially means that choosing a palette of warm colors or cool ones is always a smart idea. You can also mix a few warm tones with some cool ones (I do that all the time), and it will create an interesting composition. Again, experiment! Have a blast!

Practice your layering and blending. Layering and blending are two very easy-to-learn concepts, but if used correctly they will make your drawing look extremely cool, almost alive! (See page 4 for more info on layering and blending.)

Here are a few examples of winning color palettes for you.

Monochromatic
Different shades of the same color. One easy decision—one color—and then you can work with every single shade of that color.

Grayscale
This may seem counterintuitive for coloring, but you can create some very cool art using different shades of gray. Your pieces can look really intriguing if you use the right tones. Black, white, and everything in between.

Primary Colors and Variations
Who said the old blue, red, and yellow are boring? Try palettes with variations of these colors—aqua blue, peachy pink, lemonade yellow—and make some amazing colorings!

Layering and Blending

As I said earlier, these are two of the most useful techniques when it comes to coloring. They can help you give structure, shading, and contrast to your design, and they're super easy to learn. In the following steps, I will show you layering and blending with alcohol-based markers, but many drawing mediums will do just fine. You can use colored pencils, crayons, ink pens, paint pens, gel pens, or watercolors and achieve very similar results, though the quality of your blends will depend on the particular medium and on the quality of the products.

1 Base tone

Lay down a base layer with your lightest color. Make sure it's flat and even for best results. If you're using colored pencils, make sure you always apply the color in light strokes, without pressing too hard on the paper.

2 Middle tone

Proceed by laying down your middle tone on part of the first layer, and then use strokes of your lightest color to smooth out the color and make the shading look more gradual.

3 Dark tone

Time to color in with your darkest value! Repeat the process shown in the previous step, first applying your darkest tone and lightly smoothing out the transition with the middle tone. Then go once more over the entire area with your lightest color for maximum blending and smoothness.

4 Details (optional)

Now for the fun part! When the ink/pigment is nice and dry, you can add details and patterns using many different mediums (gel pens, paint pens, white ink, fine-tip markers, etc.). Go nuts!

Bonus Tips

- **Perseverance**

 Let's say you've colored a portion of the design, but you don't really like it. Keep going and don't give up! Sometimes you will create some of your best pieces working through bad starts—trust me, I've experienced this many times myself.

- **Relax!**

 One of the most beneficial aspects of coloring is its ability to relax you and put you in a good mood. Try listening to some soothing music or audiobooks while you color for an even better experience. I personally love listening to original movie soundtracks while I work, but any genre might work great for you.

- **Paper Protection**

 If you're coloring directly in the book, and you notice when you're coloring with a certain medium (like alcohol-based markers) that some of the ink is bleeding through the page, just place a blank sheet of paper beneath the drawing; this will protect the design on the following page of the book.

- **Tool Maintenance**

 When using colored pencils, always make sure to keep them sharp and be careful not to drop them. This will preserve the pigment inside and make them last a lot longer. If you're using markers, always put their caps back on when you're not using them. If the ink inside dries up too much, the marker will stop working.

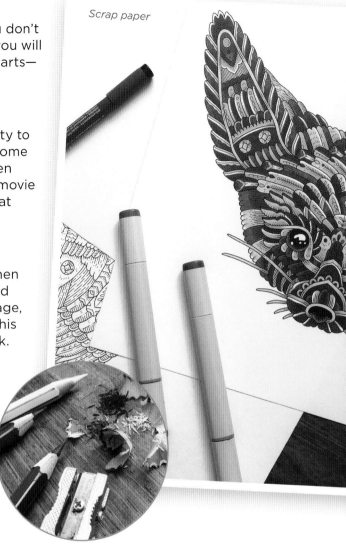

Scrap paper

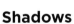

- **Shadows**

 When coloring in shadow areas, don't use a black pencil or marker. Try using a complementary color to the one you have in the lighter areas (for example, if that element of your drawing is orange in its light and mid-tone areas, use a shade of blue to build up your shadow). This will create a nice realistic soft brown/gray shadow.

Lightest to darkest

Darkest to lightest

- **Values Order**

 Always apply colors from the lightest to the darkest. This way you can achieve far better blending and gradients, and you can also go over mistakes with a darker tone if you mess up.

What's your spirit animal?

Personal animal totems have historically existed in many cultures, though the most well-known today are Native American spirit animals. What a lot of people don't realize is that your spirit animal isn't necessarily the same creature throughout your entire life. Most people go through many life changes and need the guidance of a different animal—with a different personality and purpose—at different points. So while it's popular to define yourself by a single animal, remember that you're not pigeonholed into a single animal forever! Take this quiz to see which of 5 common spirit animals might be guiding you right now—and then continue on to the rest of the book to meet the animals that may be guiding you in the future!

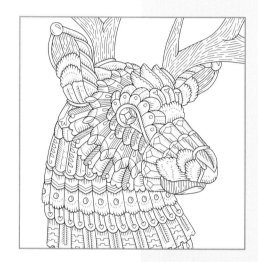

1 **When out to dinner with others, you are the member of the group who:**

A. Sits quietly, taking in all of your surroundings and listening closely to the stories the rest of the group is sharing

B. Leads conversation and delegates a good time for everyone at the table

C. Politely handles any problems with the meal or issues with the waiter

D. Asks questions and seeks deeper meaning in the thoughts and ideas brought up in conversation

E. Provides humor and entertainment to get the group loosened up and having fun

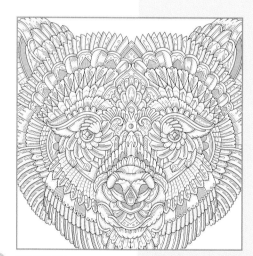

2 **If you had to choose one word to describe your personality, it would be:**

A. Sensitive

B. Confident

C. Graceful

D. Inquisitive

E. Adaptable

It was a lot of fun to research the personalities of so many spirit animals for this book. There is a ton of information out there from a lot of different sources, so keep in mind that the personalities described in these pages might be different in various mythologies and cultures. Do your own investigating of the spirit animals that call to you!

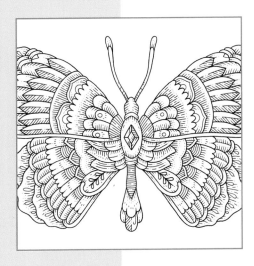

3 If a loved one has been hurt by someone close to him or her, your reaction is to:

A. Lend them a dedicated ear so they may speak about their troubles and be heard without interruption *also*

B. Become very protective of your loved one and go speak one-on-one with the person who has upset them

C. Offer them advice on how to overcome the pain they feel in order to grow from the experience

D. Try to understand why your loved one's companion has been behaving so negatively

E. Ease the pain by making your friend laugh and using diversions to take their mind away from the situation

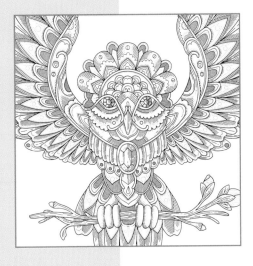

4 In your opinion, the best way to celebrate a really great day is by:

A. Curling up in your favorite spot to relax and bask in the happiness you feel

B. Inviting your friends to come out and celebrate with you

C. Writing about it in your journal and letting it be a model for days to come

D. Individually savoring and appreciating all of the individual things that made the day so special

E. Congratulating yourself and treating yourself to your favorite snack

5 What time of day is your favorite?

1st **A.** Dusk. It is soft and gentle, with the day's edges fading and losing their harshness. All the creatures are beginning to settle down for a cozy night.

B. Afternoon. The sun's warmth fills the air with energy and all the creatures bustle around living their lives.

2d **C.** Early morning. The sunrise is fresh and vibrant, transforming the dark into a brand new, glorious day.

D. Night. The darkness is serene, and lends a clarity and focus that's difficult to find during the bright and busy day.

E. Midday. The clear sky creates beautiful sun-bathed fields and tucked-away shadows, perfect for both fun activities and secret liaisons.

Results
Mostly As: Deer *(pages 75–76); Mostly Bs: Bear (pages 31–32); Mostly Cs: Butterfly (pages 37–38);*
Mostly Ds: Owl (pages 73–74); Mostly Es: Fox (pages 69–70)

7

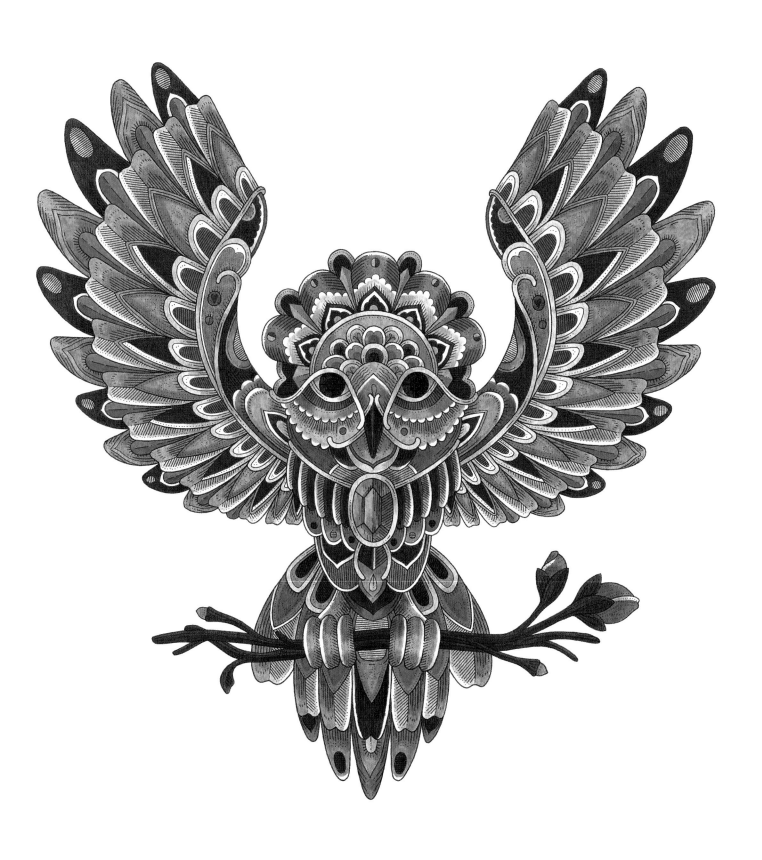

Owl, page 73.
Alcohol-based markers (Copic Sketch). Color by Filippo Cardu.

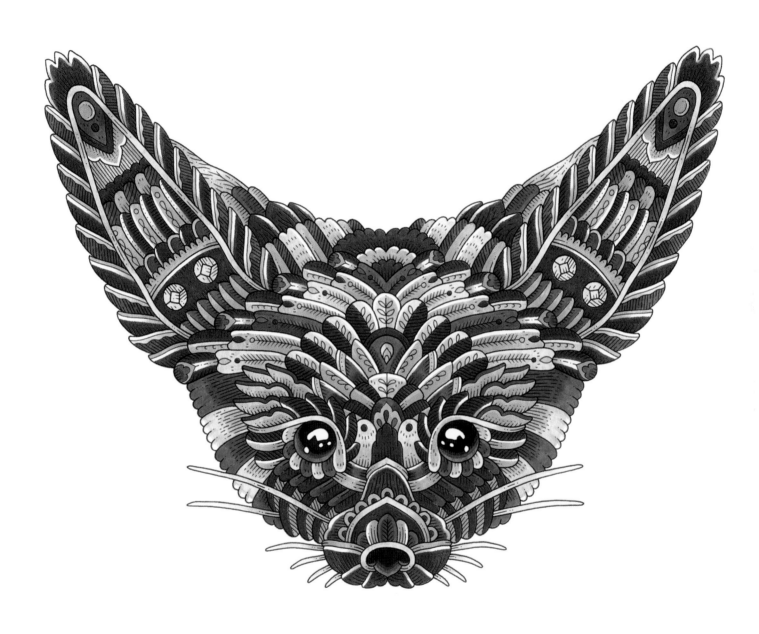

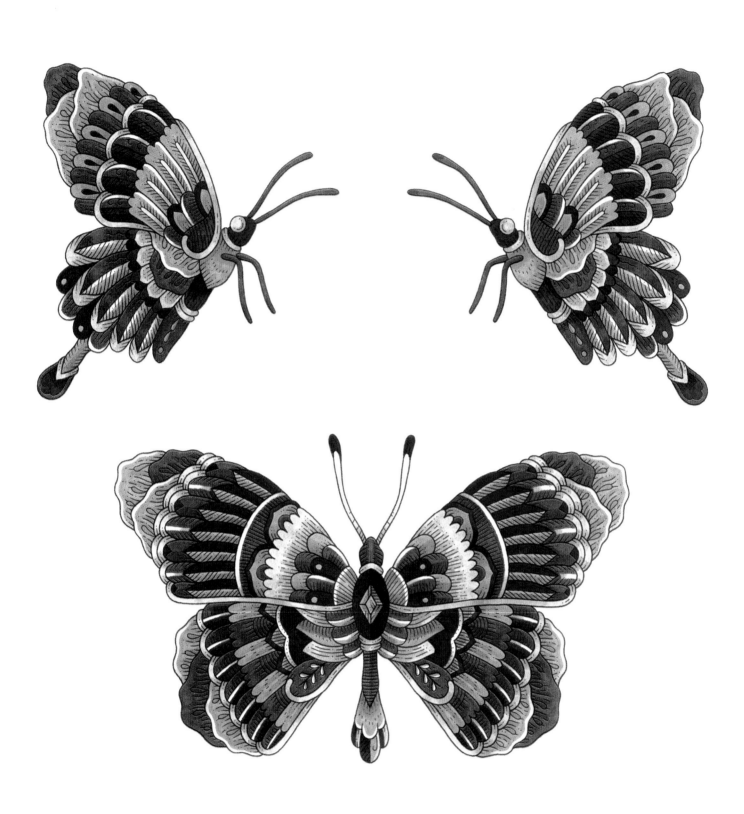

Butterfly, page 37.
10 *Alcohol-based markers (Copic Sketch). Color by Filippo Cardu.*

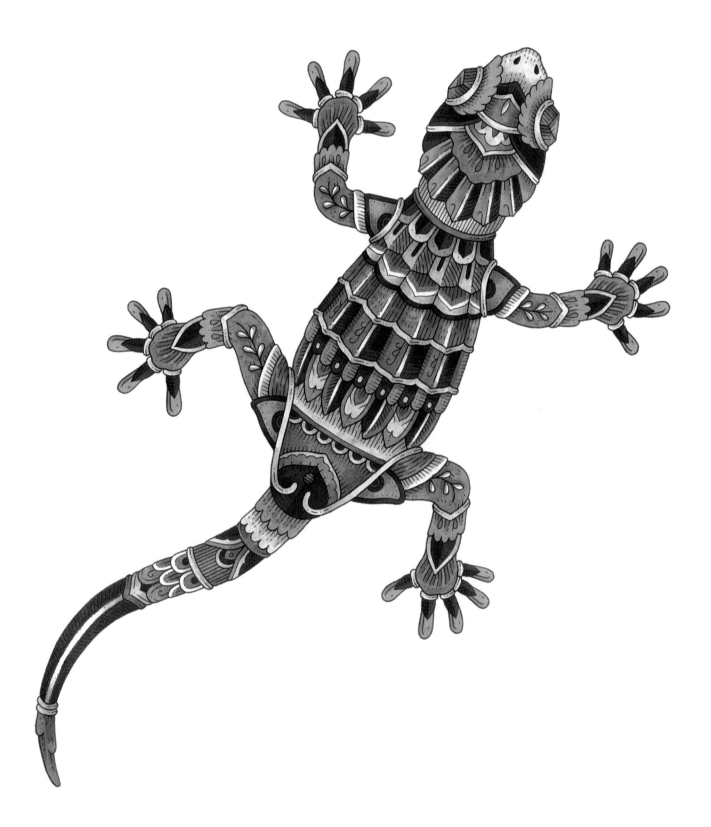

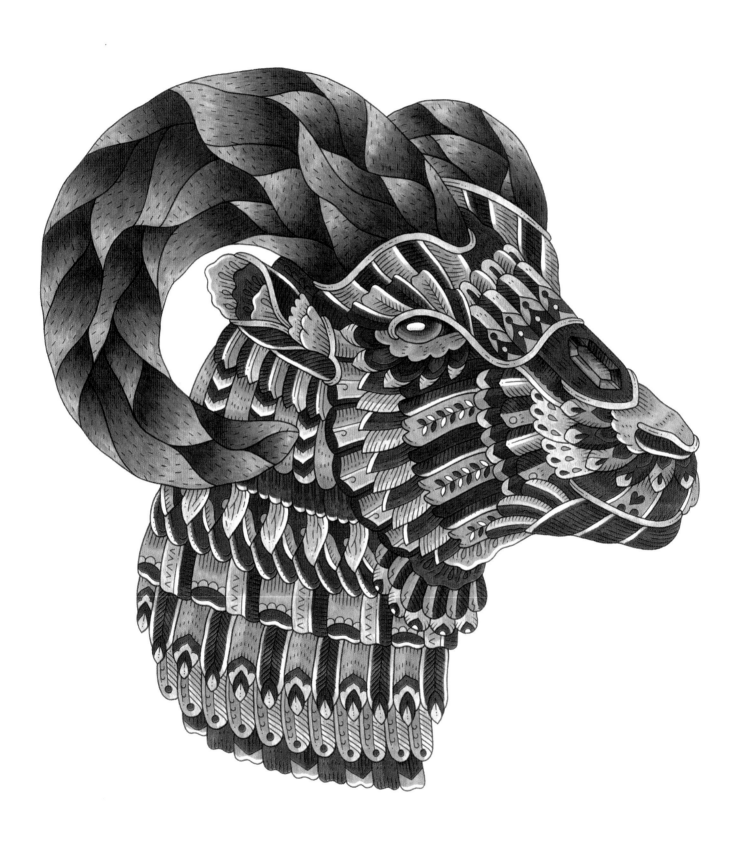

Ram, page 71.

Alcohol-based markers (Copic Sketch). Color by Filippo Cardu.

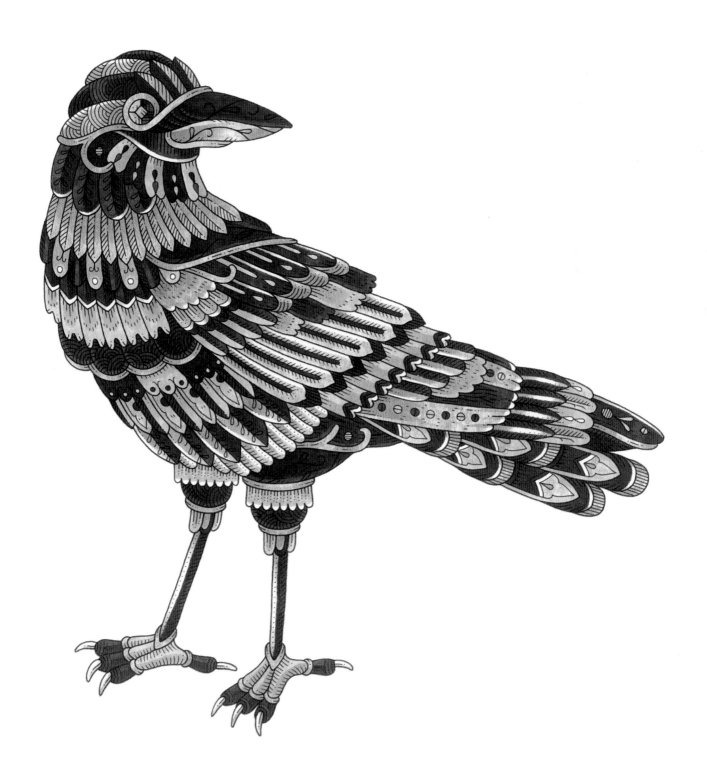

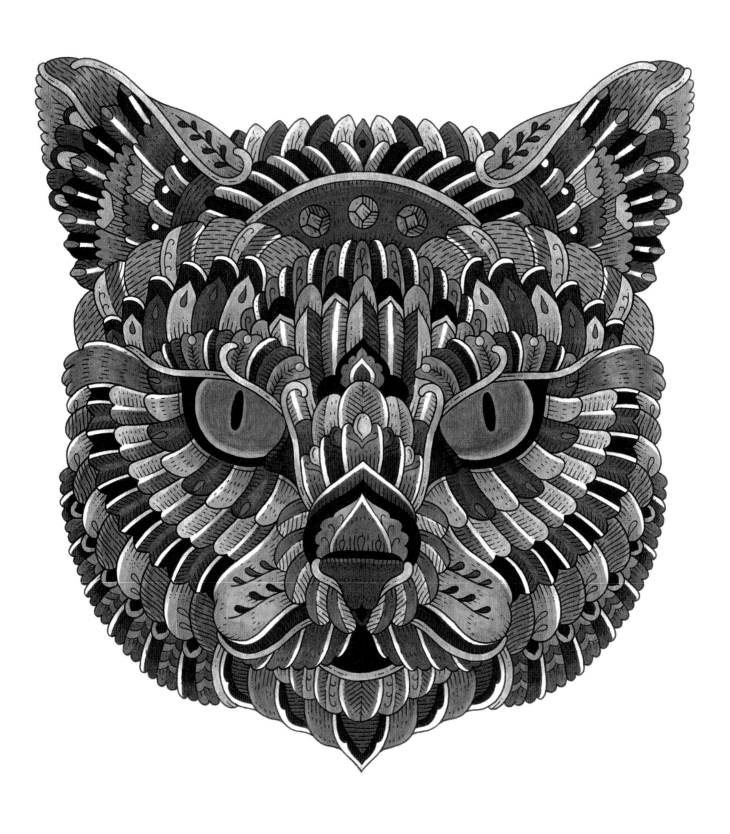

Cat, page 39.
Alcohol-based markers (Copic Sketch). Color by Filippo Cardu.

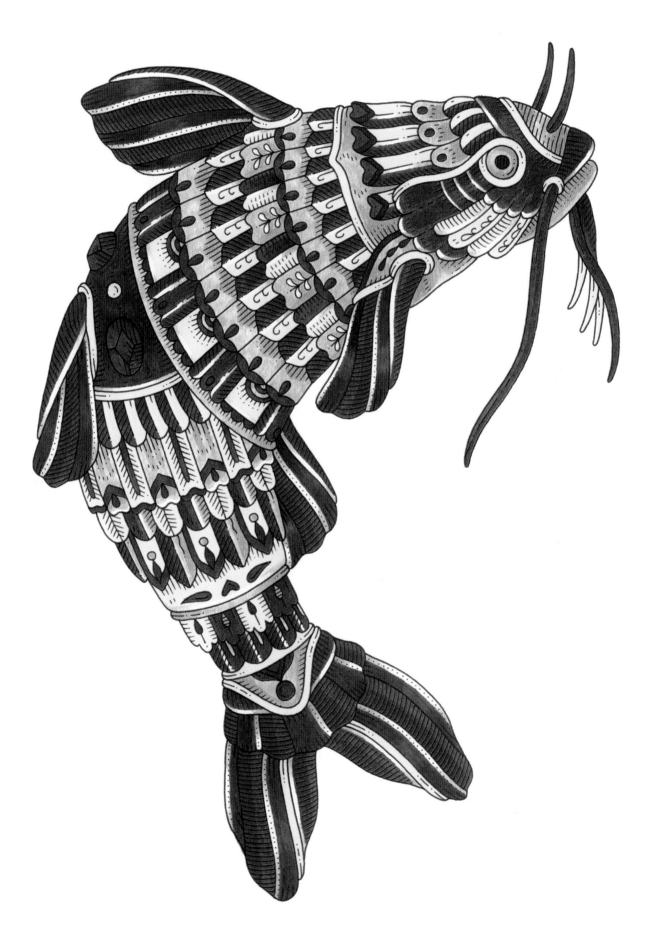

Catfish, page 67.
Alcohol-based markers (Copic Sketch). Color by Filippo Cardu.

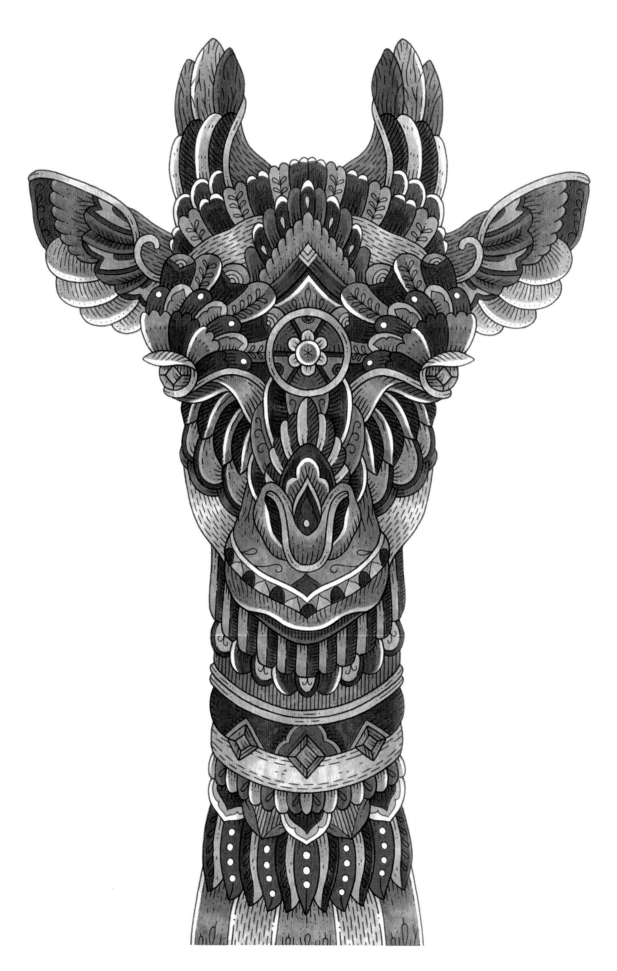

Giraffe, page 65.
Alcohol-based markers (Copic Sketch). Color by Filippo Cardu.

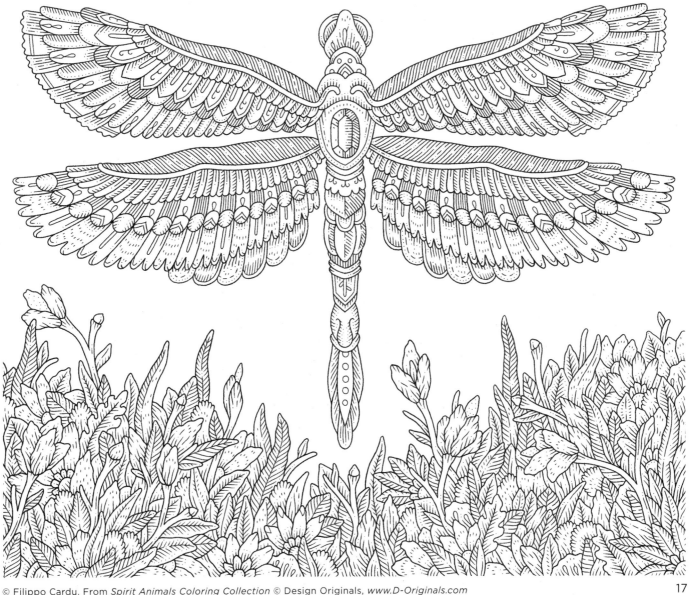

17

To exist is to change, to change is to mature,
to mature is to go on creating oneself endlessly.

—Henri Bergson

Dragonfly

You possess the power of light and transformation. You have the ability to help others to transform and grow to their full potential. Even in dark times you have the ability to see by surrounding yourself with lightness and positivity.

Key traits: flightiness, lightheartedness, strong imagination, joy

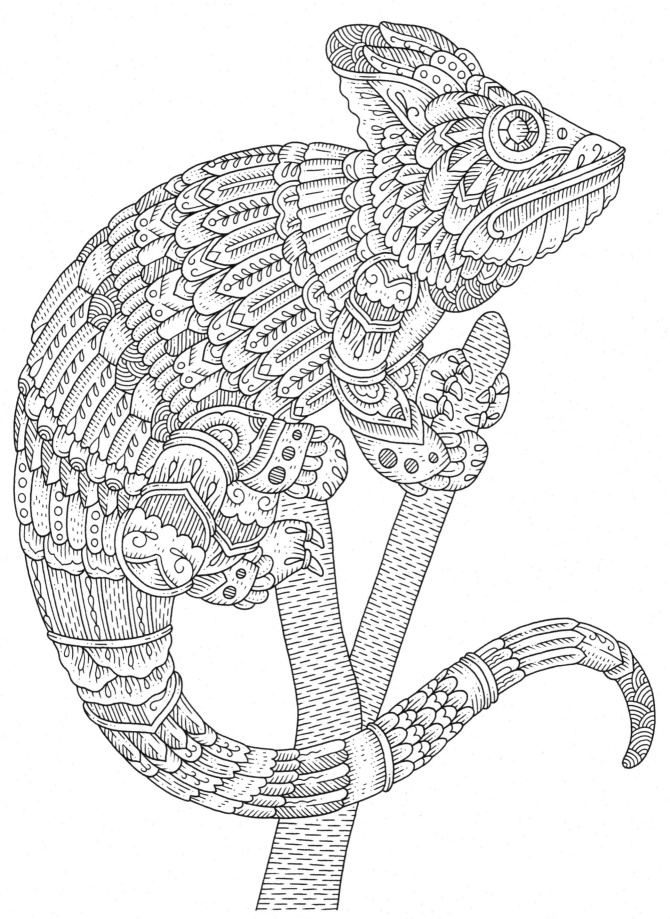

The only way to make sense out of change
is to plunge into it, move with it,
and join the dance.

—Alan Watts

Chameleon

You are extremely resourceful and accepting of change. Acceptance of change difficult for many people, but you have a patience and intuition about you that knows something better is in the winds.

Key traits: change, perception, resourcefulness, sensitivity

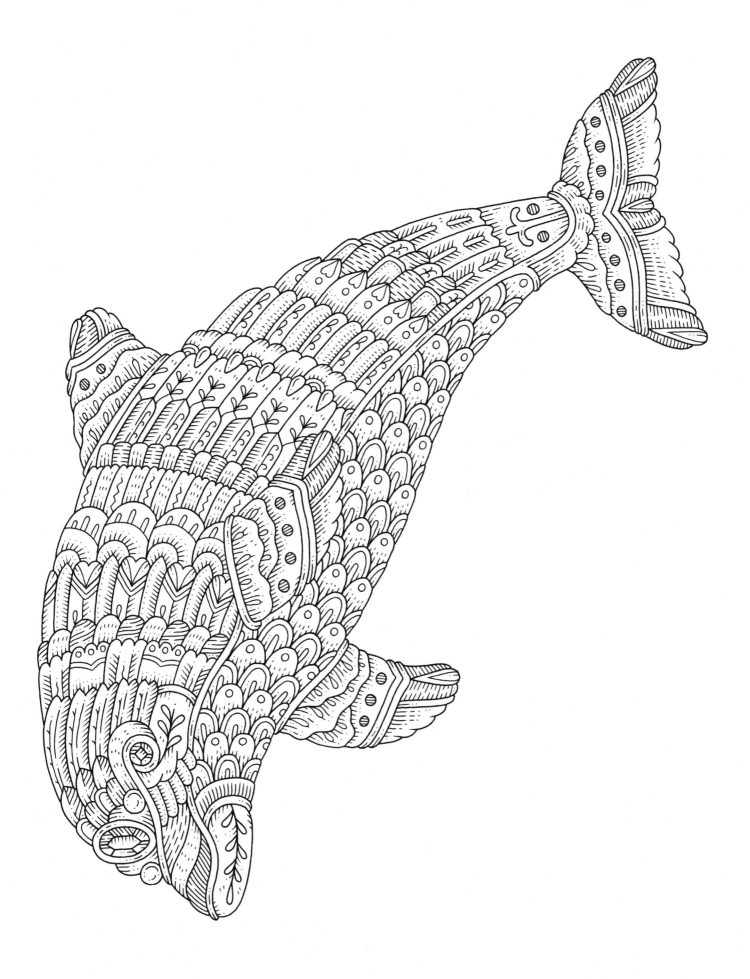

21

Perhaps imagination is only
intelligence having fun.

—George Scialabba

Dolphin

The dolphin is a symbol of playfulness, intelligence, and deep emotion.
You are able to keep harmony and balance within your life. You have the
ability to make work playful, but also possess the ability to guide and protect.
You feel deeply for others and instill a great trust.

Key traits: kindness, salvation, playfulness, deep emotion,
harmony, inner strength

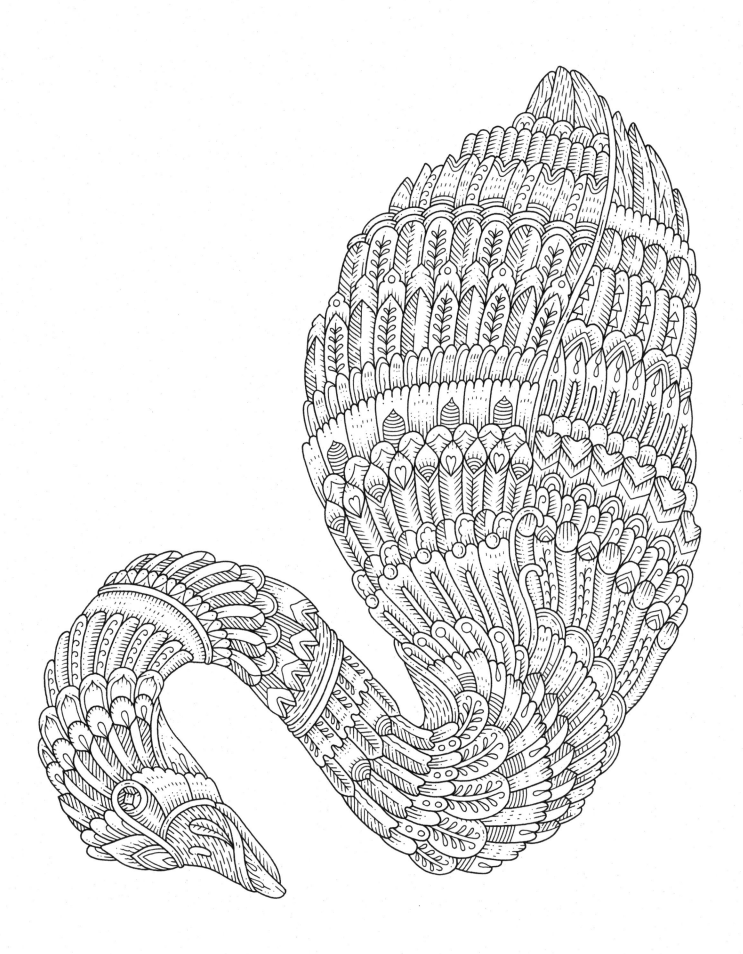

Since love grows within you, so beauty grows.
For love is the beauty of the soul.

—St. Augustine

Swan

The swan is a symbol of love. You have a deep understanding of love
and love deeply. You might find love at a young age
and sustain this relationship for a lifetime.

Key traits: grace, balance, innocence, love, elegance, transformation, dreams

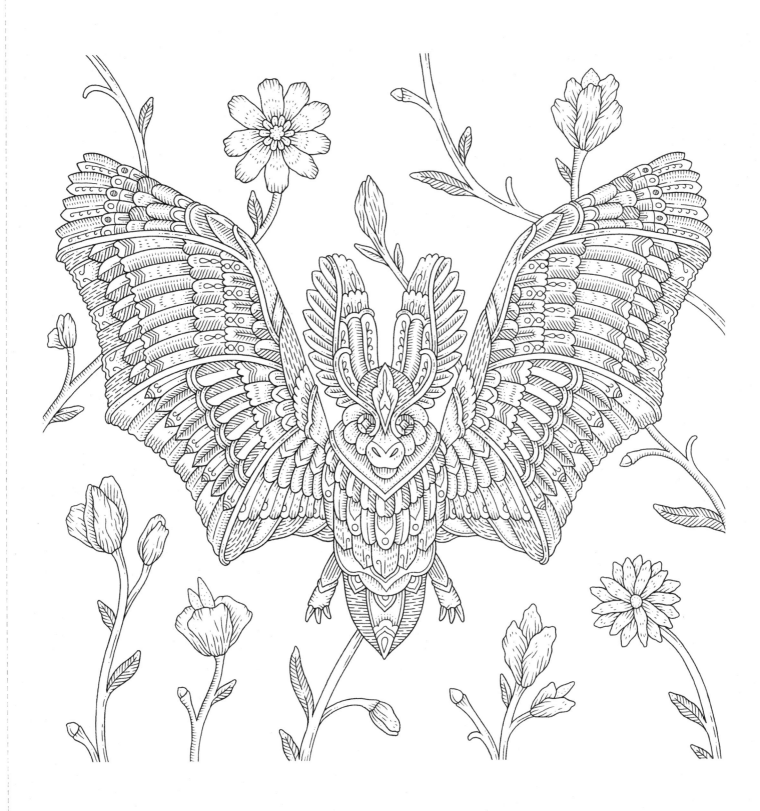

One way to open your eyes to unnoticed beauty is to
ask yourself, "What if I had never seen this before?
What if I knew I would never see it again?"

—Rachel Carson

Bat

You are a keen observer and a good listener. You have the ability to see
through the haziness and discover what truly matters. Like a bat,
you have deep family ties. You maintain these relationships by being a
good listener and nurturing those most important to you.

Key traits: perception and awareness, secrecy, listening

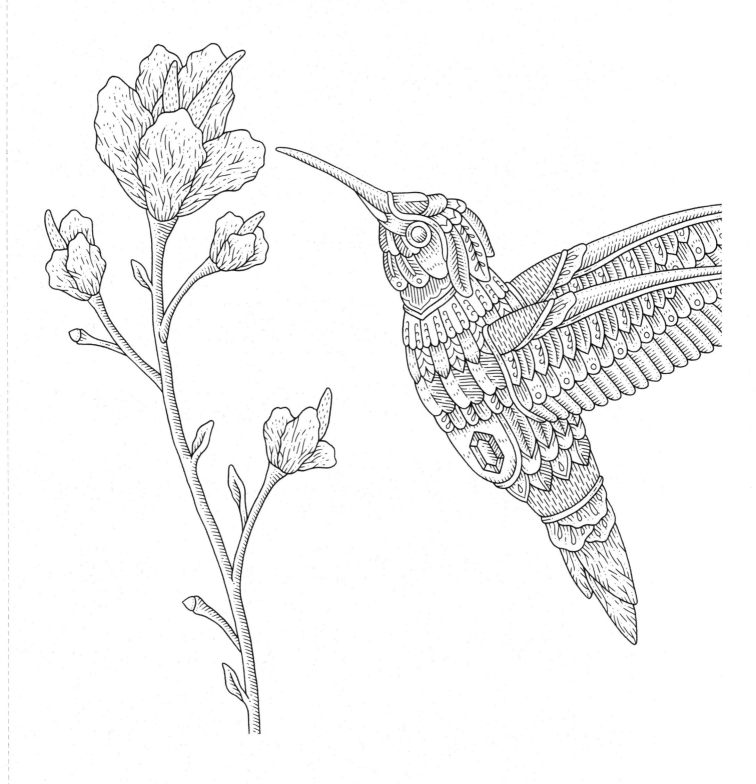

You have to decide what your highest priorities
are and have the courage—pleasantly, smilingly,
nonapologetically—to say "no" to other things.
And the way to do that is by having
a bigger "yes" burning inside.

—Stephen Covey

Hummingbird

You have a joyfulness, playfulness, and swiftness about you.
You acknowledge the little things in life and enjoy every moment. You are
able to be persistent and resilient in the face of negativity.

Key traits: enjoyment of life, lightness of being, joy,
resilience, swiftness, playfulness

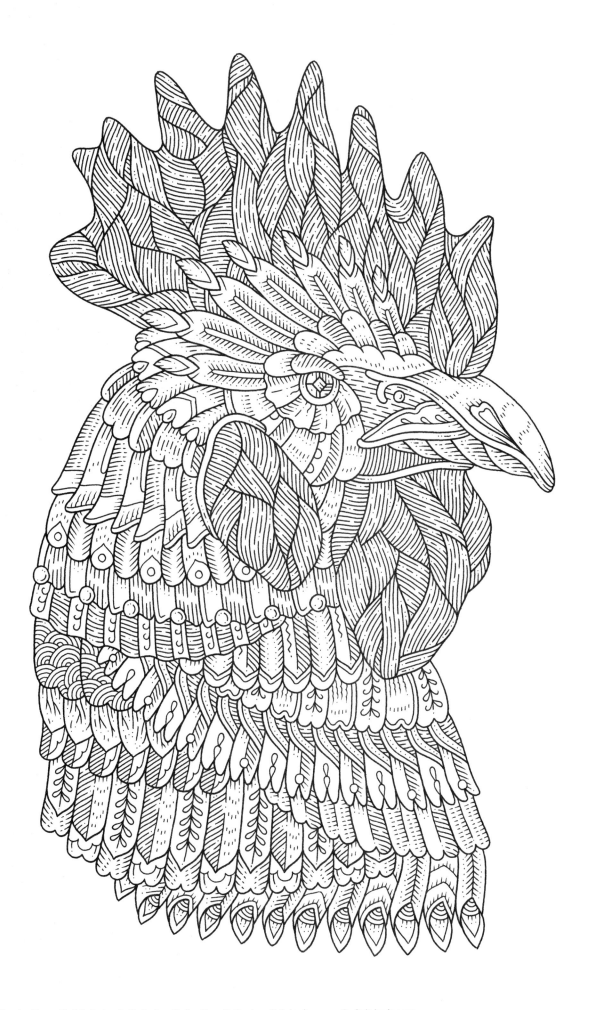

Be bold enough to use your voice, brave enough
to listen to your heart, and strong enough
to live the life you've always imagined.

—Unknown

Rooster

You have a voice and something to say. Use this to help others who are
too shy to stand up and speak. You are persistent and very in touch with
your fiery side. Continue to be confident and strut your stuff.

Key traits: persistence, uniqueness, honesty, watchfulness

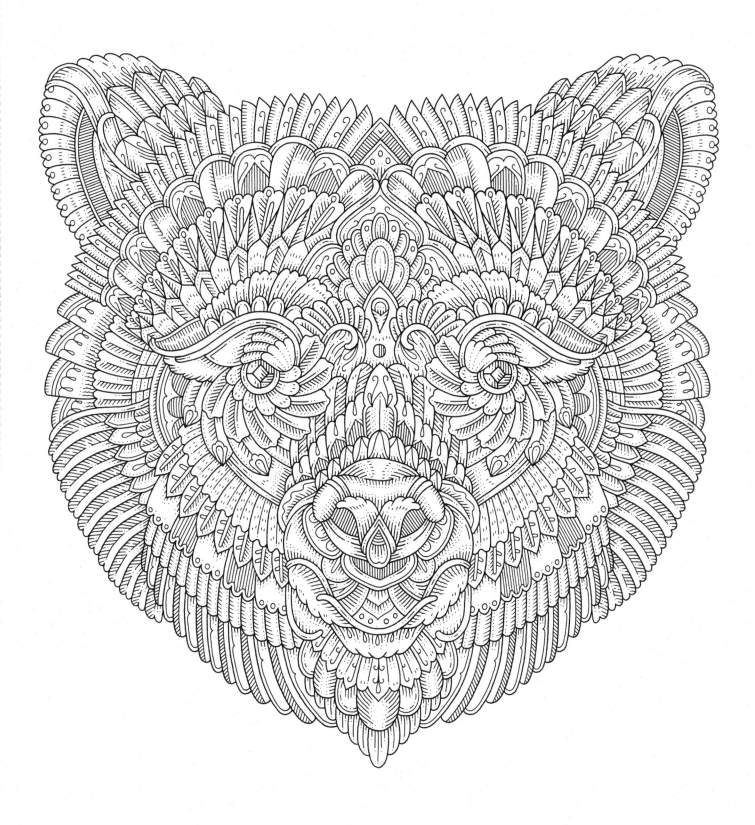

The truly brave are soft of heart.

—Lord Byron

Bear

The bear represents strength, confidence, and fearlessness.
You are a leader; others can rely on you for support and strength. Though you
may be tough, you have a nurturing and protective side as well.

Key traits: strength, confidence, guardianship,
in touch with the earth and cycles of nature

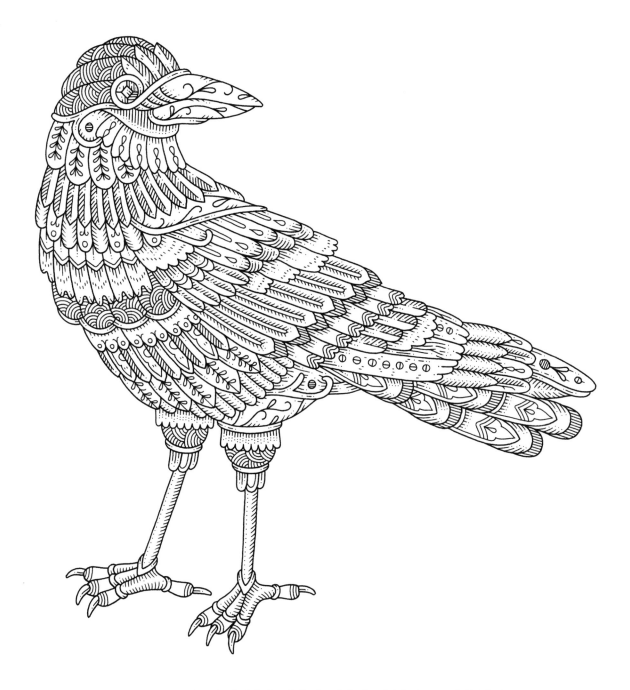

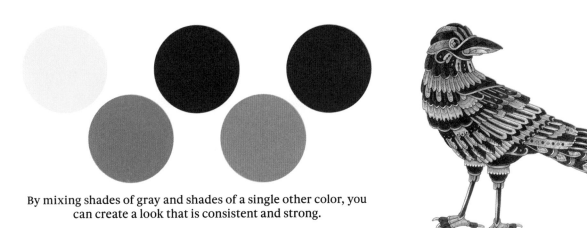

By mixing shades of gray and shades of a single other color, you can create a look that is consistent and strong.

How can you know what you're capable of
if you don't embrace the unknown?

—Esmeralda Santiago

Crow

You have the ability to adjust to the ebbs and flows of life. Representing magic,
crows exist all over the world and remind us that magic is everywhere. You
have a mystery about you that is special beyond compare.

Key traits: higher perspective, shape shifting, life, mysteries

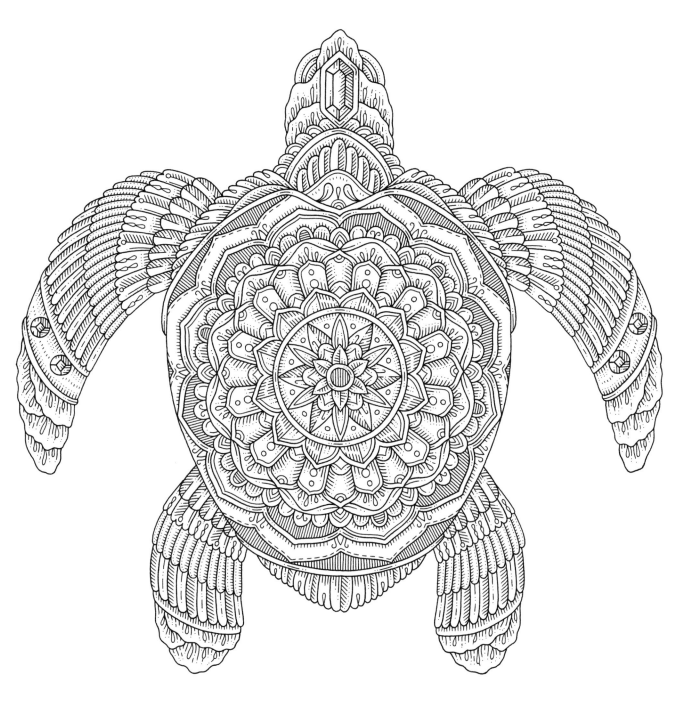

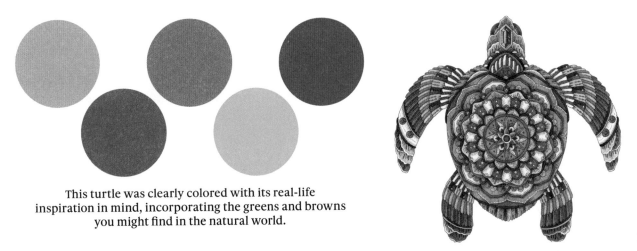

This turtle was clearly colored with its real-life
inspiration in mind, incorporating the greens and browns
you might find in the natural world.

Try to be like the turtle—
at ease in your own shell.

—Bill Copeland

Turtle

You possess navigational skills that are hard to beat. You know
where you are going, but may need the occasional reminder to pace yourself.
Sometimes you have a tendency to hide within your shell, but if you use your
inner strength, you will be able to conquer both land and sea.

Key traits: strength, protection, nurturing, peace

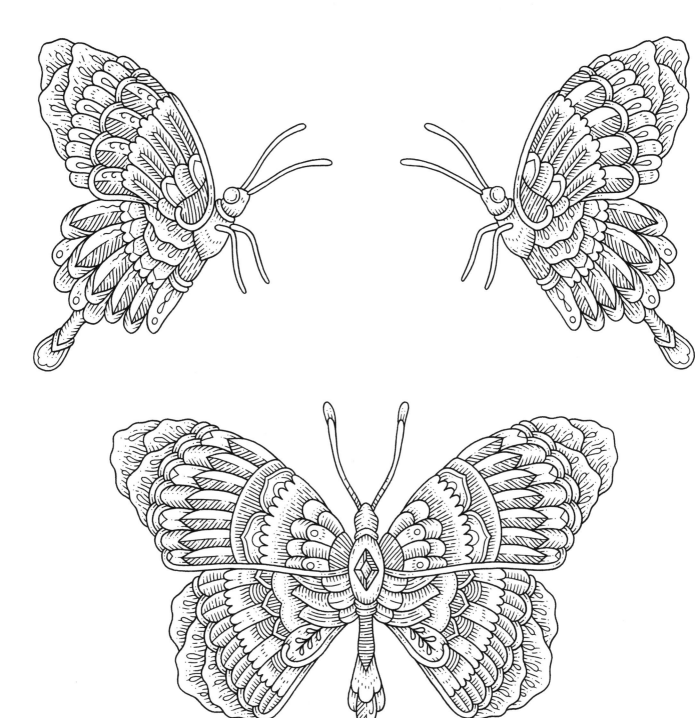

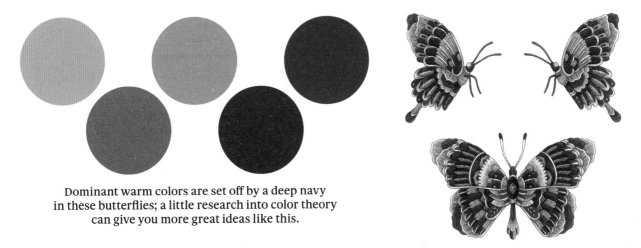

Dominant warm colors are set off by a deep navy
in these butterflies; a little research into color theory
can give you more great ideas like this.

If we don't change, we don't grow.
If we don't grow, we aren't really living.

—Gail Sheehy

Butterfly

Like a butterfly, you can handle change with grace and emerge stronger.
You are vulnerable, light, and graceful.

Key traits: transformation, lightness, rebirth, grace, vulnerability

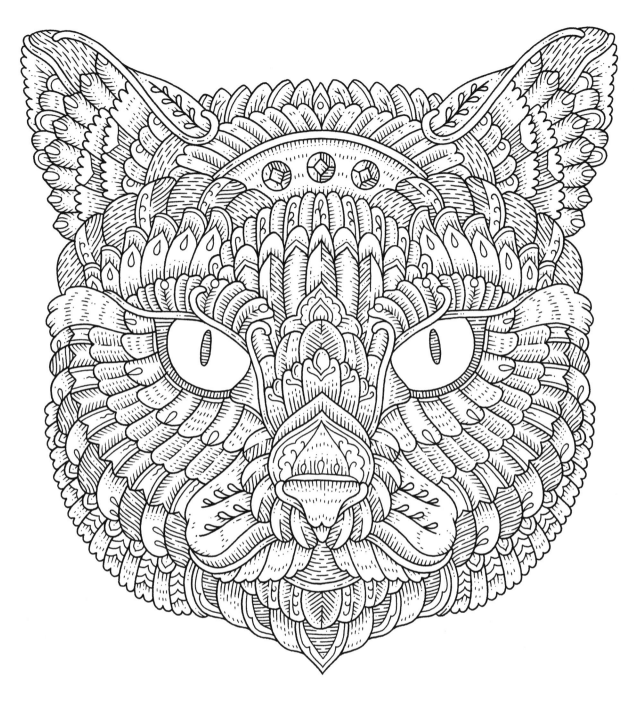

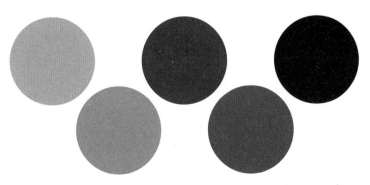

Primary red and blue are toned down with a rich caramel
to create this colorful cat face.

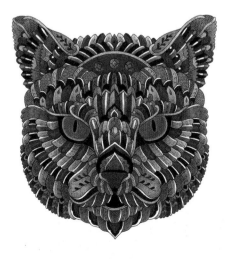

If you live the questions,
life will move you into the answers.

—Deepak Chopra

Cat

You have the mettle to explore the unknown. You are curious
to know what makes an object tick and eager to find solutions.
You have a strong sense of self, and though you are confident and choose
your own way, be wary of being too reclusive.

Key traits: exploration of the unknown, curiosity, relaxed connection with self

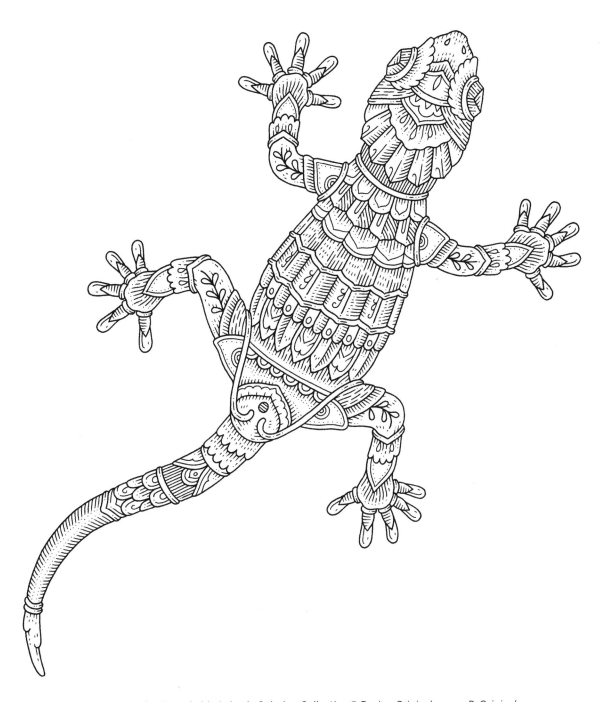

Three different shades of blue, from an almost-black navy to a vivid aqua, are mixed with subtle gray details for a stunning effect.

Vision is the art of seeing what is invisible to others.

—Jonathan Swift

Lizard

You have a sixth sense—a way of sensing what is going on
and if there is a potential threat. You have a shrewdness and cunning side
that helps you to escape any bad situation you may encounter.

Key traits: vision, self-protection, shrewdness

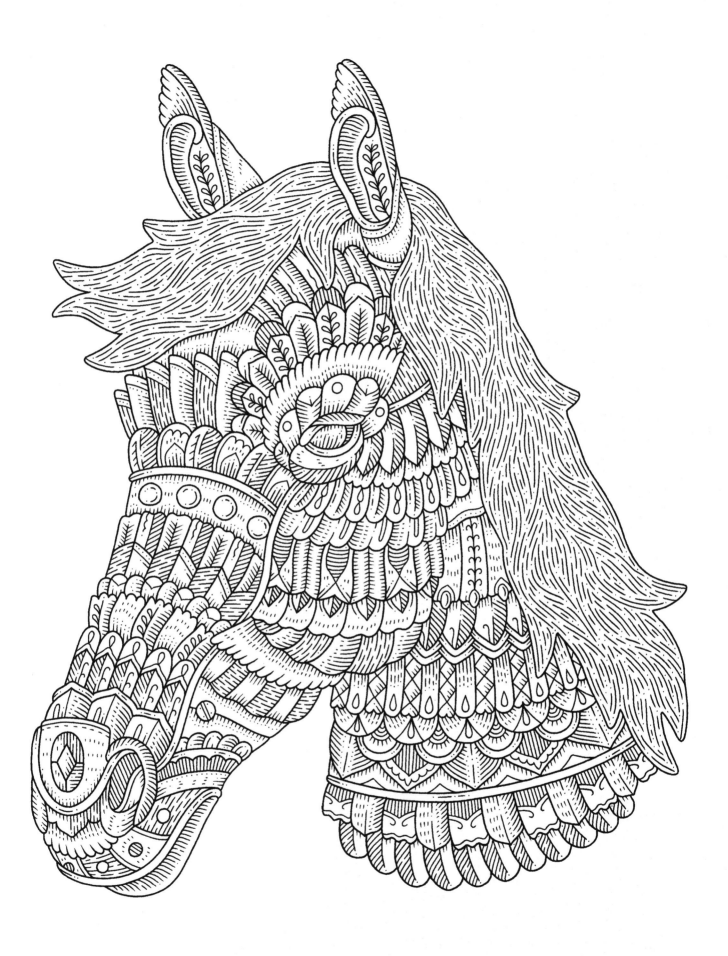

If you're gonna make a change, you're gonna
have to operate from a new belief that says
life happens not *to* me but *for* me.

—Tony Robbins

Horse

You're full of drive and passion. Though you may have a short attention span,
you love challenges and have the ability and endurance to overcome them.
You have a high energy, warm heart, and loyalty unlike any other.

Key traits: freedom, drive, power, passion, nobility

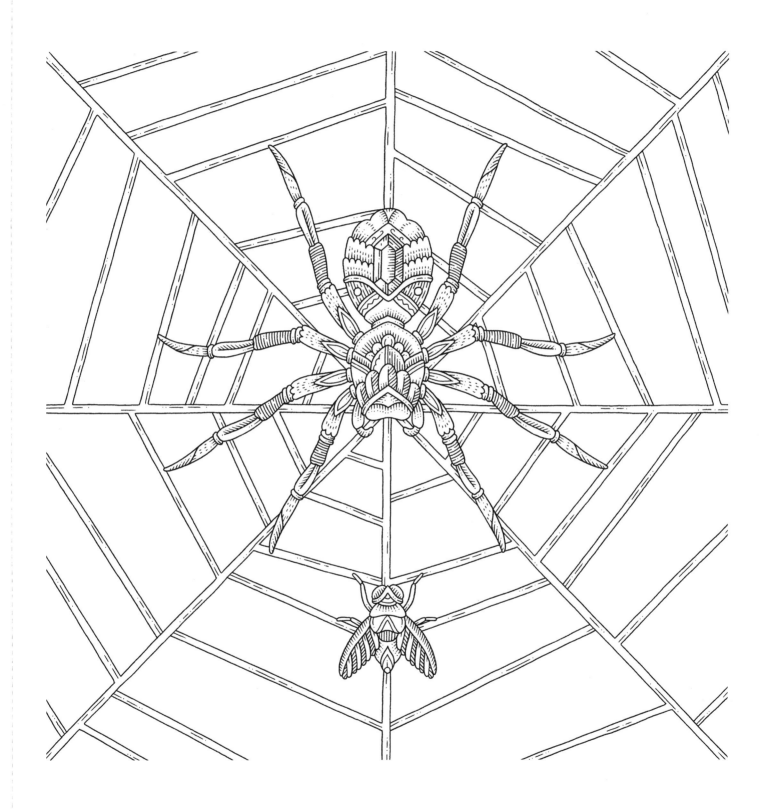

Creative isn't the way I think,
it's the way I like to live.

—Paul Sandip

Spider

The spider represents creativity. You have the ability to craft delicate objects
or ideas. You are patient as well as strong and gentle.

Key traits: creativity, craftiness, patience

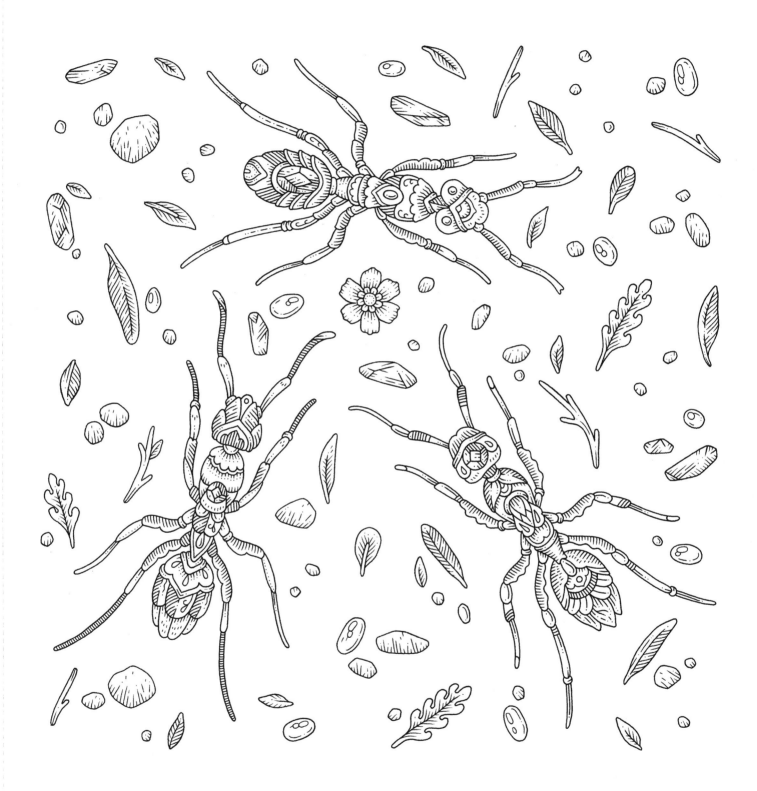

A man of knowledge lives by acting,
not by thinking about acting.

—Carlos Castaneda

Ant

You are a purposeful builder. You have a clear sight of your goals and future,
and your strong sense of unity means that you prefer to work with others
to reach these goals.

Key traits: activity, purposefulness, unity, persistence

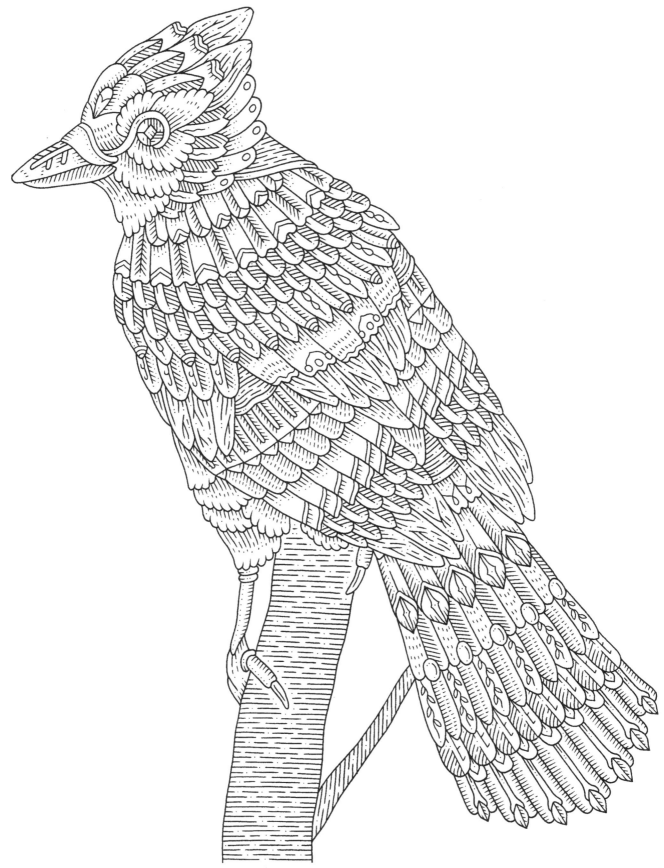

Be humble in your confidence yet
courageous in your character.

—Melanie Koulouris

Cardinal

You hold yourself with pride and have a natural confidence.
You are energetic and love life, though you do not like when others interfere
with you. You have a strong desire to defend your territory, since,
after all, it is something you are proud of.

Key traits: territoriality, pride, confidence

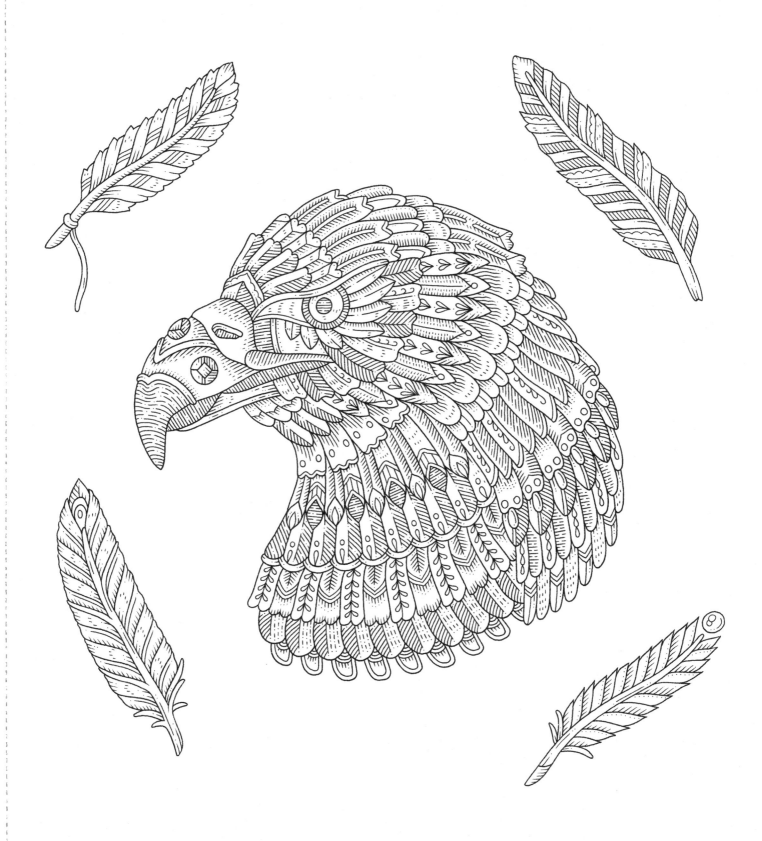

May you have the strength of eagles' wings,
the faith and courage to fly to new heights,
and the wisdom of the universe to carry you there.

—Native American blessing

Eagle

You are a free spirit that has the ability to take flight whenever you want.
You are incredibly intelligent. You are a risk taker and have the courage to trust
your instincts and go where they lead.

Key traits: divine spirit, freedom, risk taking, courage, intelligence

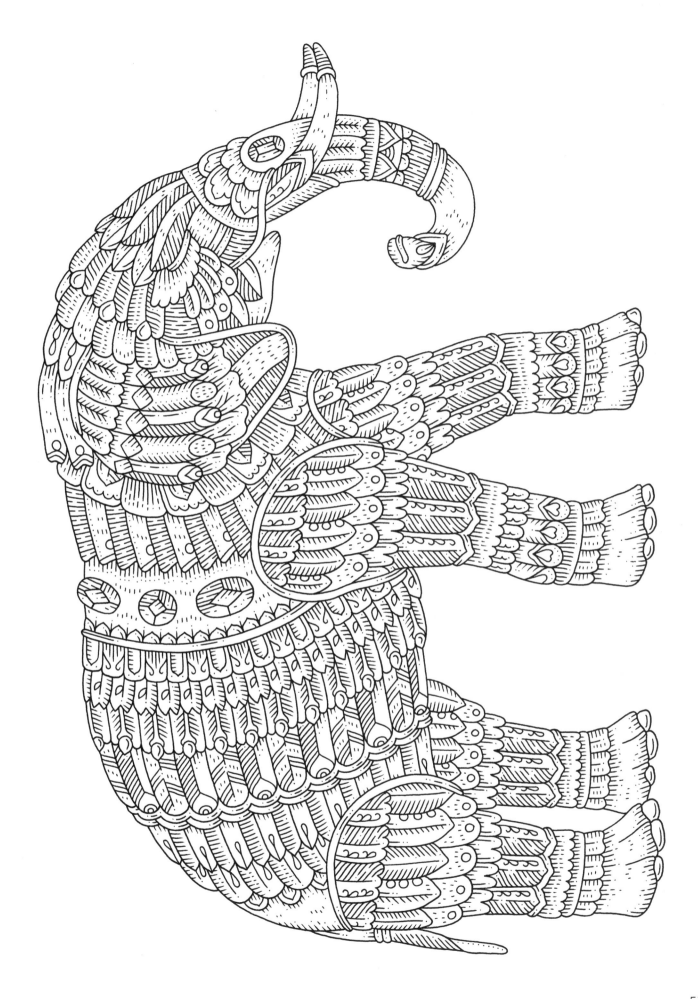

We acquire the strength we have overcome.

—Ralph Waldo Emerson

Elephant

Family is everything to you, and you will remain loyal
throughout the most difficult of times. You possess great strength
that is used for protection of those you love.

Key traits: strength, power, loyalty, royalty, pride, sense of history

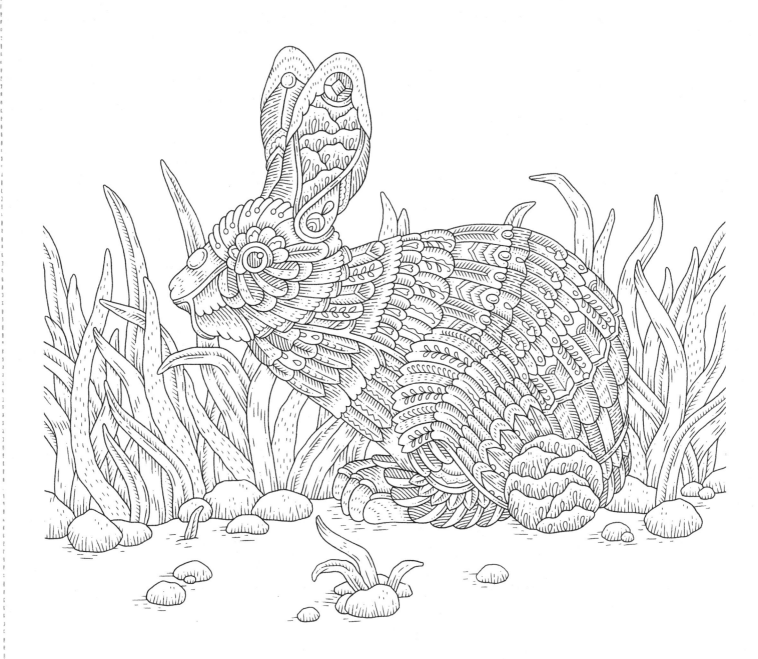

Have great hopes and dare to go all out for them.
Have great dreams and dare to live them.
Have tremendous expectations and believe in them.

—Norman Vincent Peale

Rabbit

You are high energy and often unpredictable.
This makes you alert, observational, and able to react quickly.
You have a strong sense of the right path and live by your own wits.
Use this advantage to not only help yourself, but also to help others.

Key traits: energy, alertness

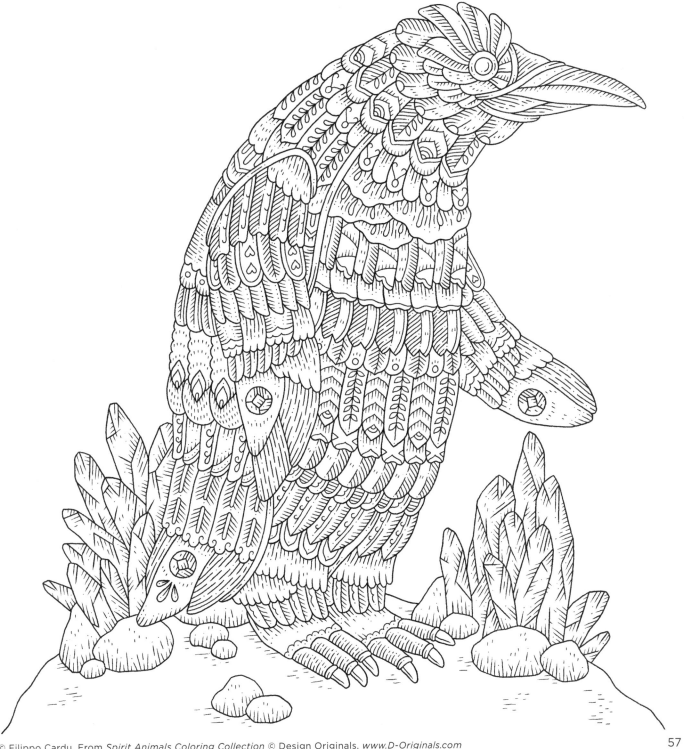

Alone we can do so little;
together we can do so much.

—Helen Keller

Penguin

You have an order and purpose for everything. This makes it easy
for you to choose where you want to go in life. You are community-minded,
working well with others and enjoying their company.

꒰꒱꒱꒱꒱꒱ ꒰꒰꒰꒰꒰꒱

Key traits: order, purpose, community

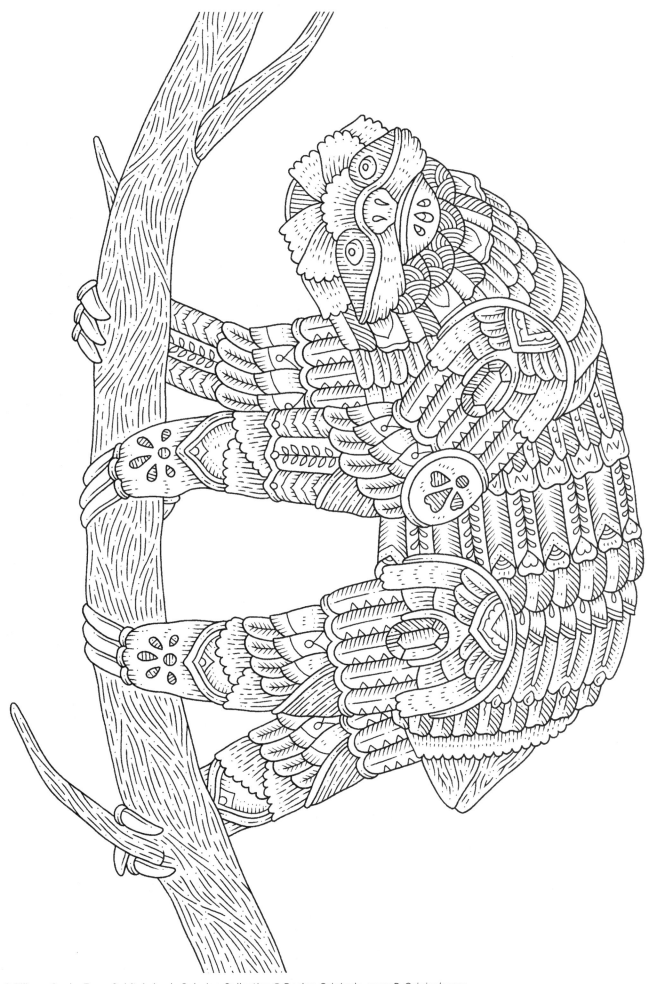

I'm in no hurry: the sun and the moon aren't, either.
Nobody goes faster than the legs they have.

—Alberto Caeiro

Sloth

You may be a slow mover, but that is fine with you. You are someone
who is comfortable in your own body and move at a pace that
works best for you. Social situations might not be your favorite,
but you value them and make the most of those moments.

Key traits: steadiness, integration with nature

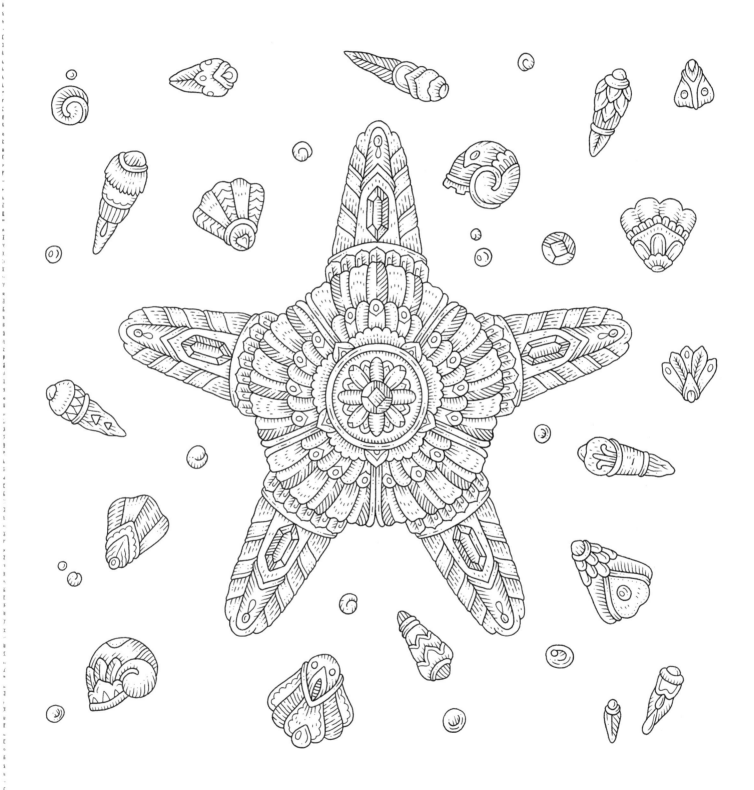

As you change your point of view,
your views bring about a change in you.

—George Alexiou

Starfish

You can easily see things from different perspectives. This gives you the chance
to discover new possibilities and opportunities. You are also easily able to
bounce back from setbacks or when you've been hurt.

Key traits: different perspectives, vision, regeneration

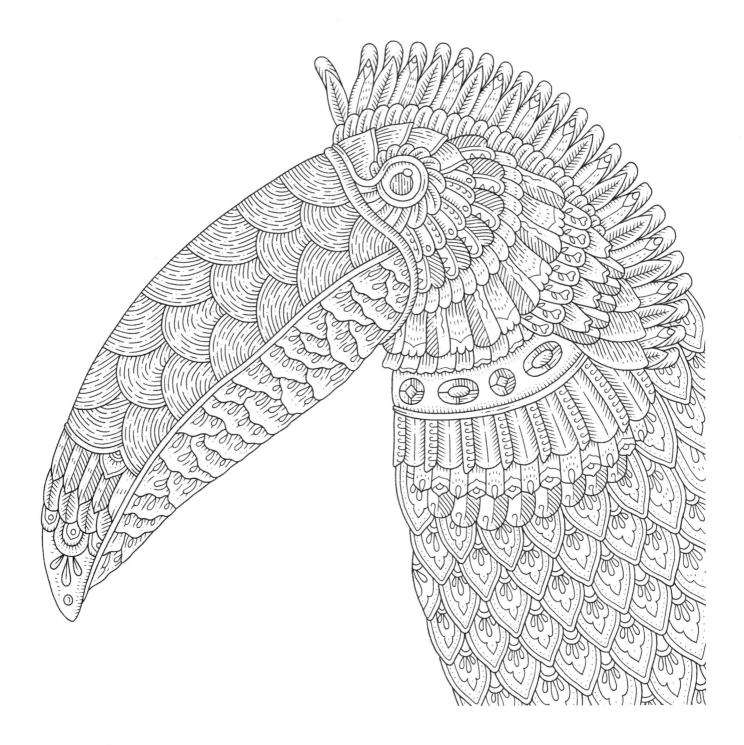

It takes nothing to join the crowd.
It takes everything to stand alone.

—Hans F. Hansen

Toucan

The toucan's colorful appearance and large bill make it stand out.
Like the toucan, you enjoy being the center of attention.
You want to be seen and heard. Though you have an entertaining personality,
do not be afraid to show your true self.

Key traits: showiness, pride, communication

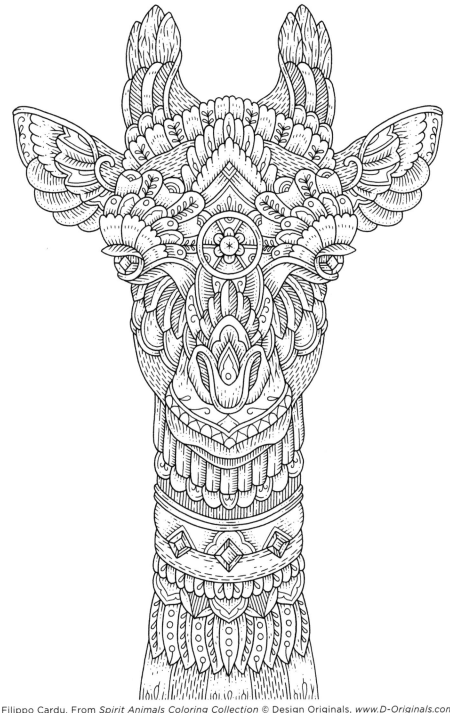

Don't forget about gray: it's a perfectly good color to mix in with more vivid tones so that you don't exhaust the viewer!

When you are a giraffe and you receive criticism from turtles, they are reporting the view from the level they are on.

—T. D. Jakes

Giraffe

If the giraffe is your totem animal, you have a high awareness or intuition. You are able to see what others cannot. You have a gentle ease and elegance that attracts others to you. You use this to your advantage to make others aware of what you see that might be out of their sight.

Key traits: awareness, intuition, attaining the unattainable, foresight, beauty

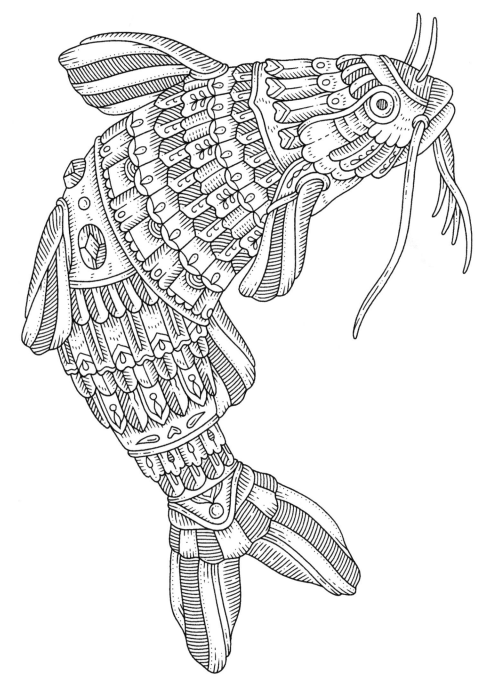

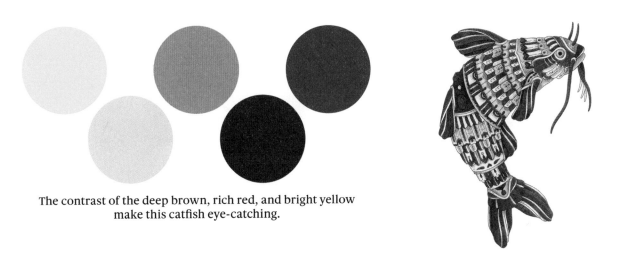

The contrast of the deep brown, rich red, and bright yellow
make this catfish eye-catching.

> Knowledge has a beginning but no end.
>
> —Geeta Iyengar

Catfish

You are someone with a great depth of knowledge. This allows you to lead a balanced and grounded life, for you have a clear understanding of emotions and so you go with the flow of life.

Key traits: knowledge, emotional expressiveness, groundedness

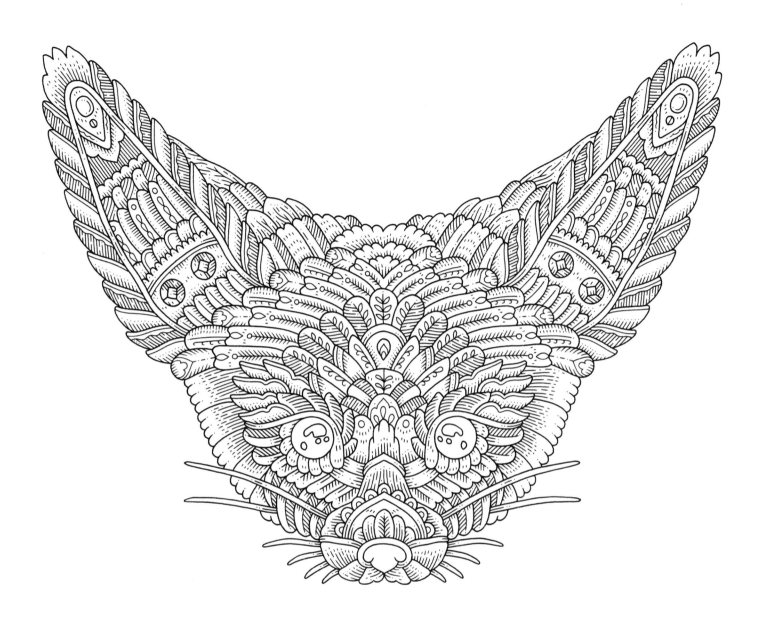

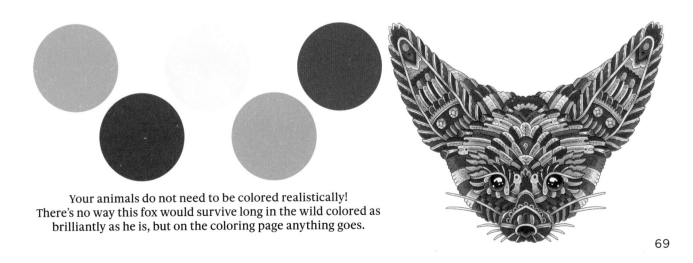

Your animals do not need to be colored realistically!
There's no way this fox would survive long in the wild colored as
brilliantly as he is, but on the coloring page anything goes.

69

"Men have forgotten this truth," said the fox.
"But you must not forget it. You become responsible,
forever, for what you have tamed."

—Antoine de Saint Exupéry, *The Little Prince*

Fox

The fox is known for being sly, smart, and adaptable. You can figure a way out
of any problem and have a strong wit, too. A peerless hunter like the fox,
you can achieve whatever you set your mind to.

Key traits: cunning, stealth, camouflage, sense of humor

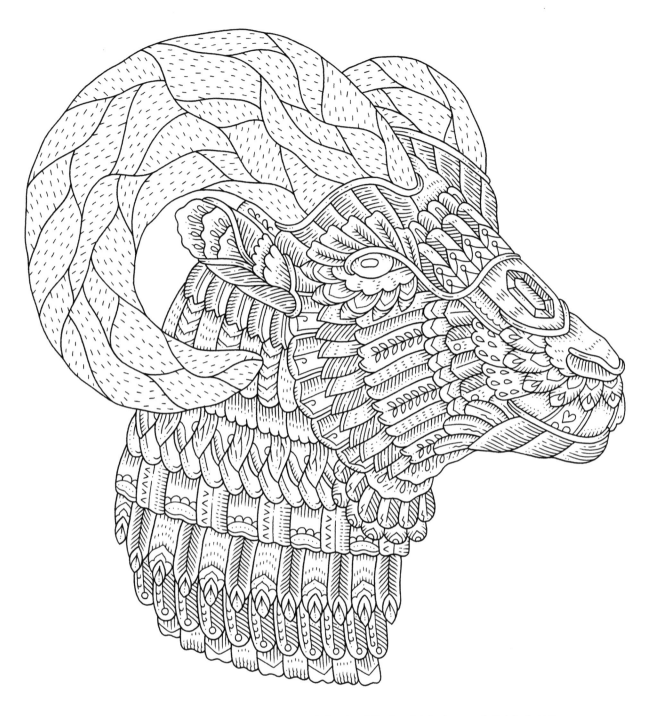

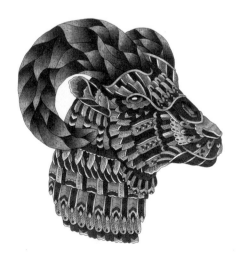

Earthy basics are a solid choice for a creature
whose four hooves are planted firmly on the ground.
The rich red keeps the piece from being boring.

The only place where your dream becomes impossible is in your own thinking.

—Robert H. Schuller

Ram

If you are like the ram, you do not give up. Despite setbacks, you have the drive to keep moving forward fearlessly. And when it's smooth sailing, you have a fiery force to reach new heights.

Key traits: force, drive, determination

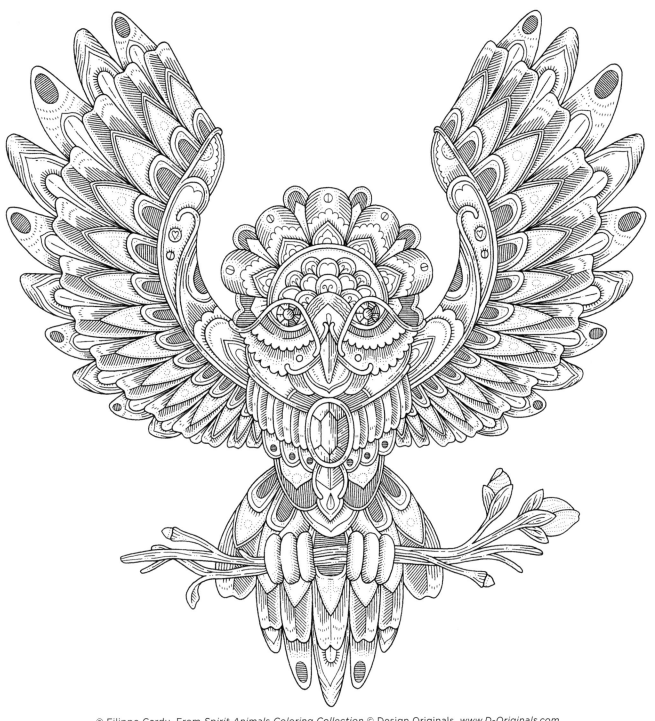

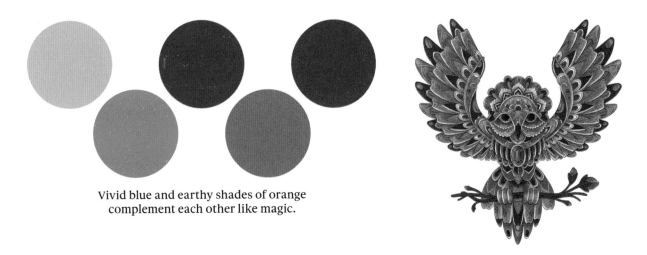

Vivid blue and earthy shades of orange
complement each other like magic.

Nothing is more precious than being in the
present moment. Fully alive, fully aware.

—Thich Nhat Hanh

Owl

You can see what is hidden easier than most, whether that is seeing past
deceptions and illusions or just seeing the truth of a situation.
You feel at home in the night and have a quiet power.

Key traits: wisdom, truth, watchfulness, secrecy, change

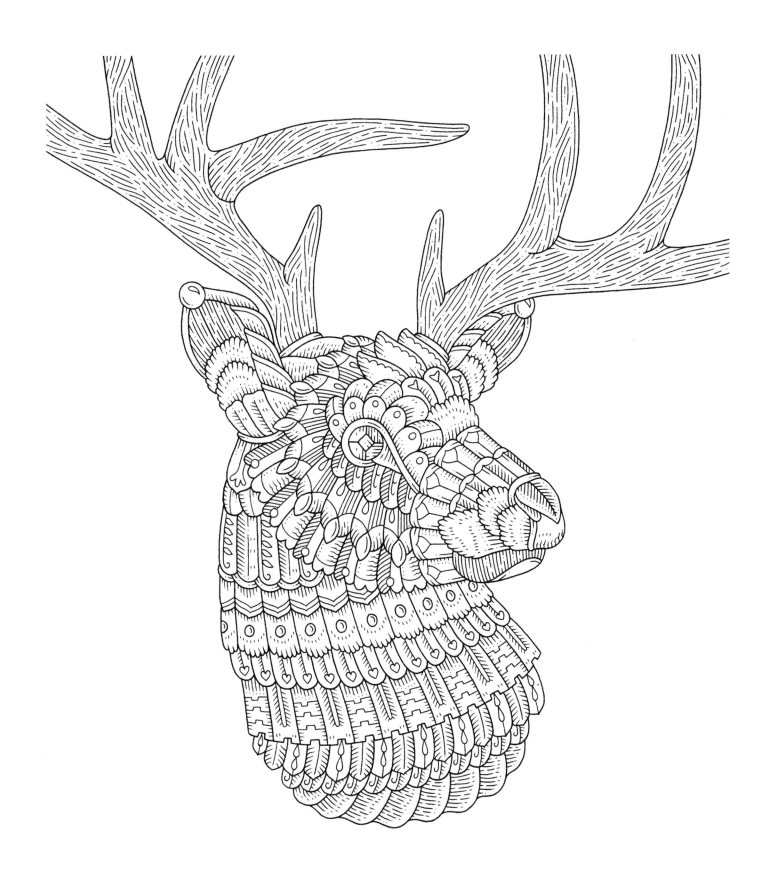

Gentleness towards self and others
makes life a little lighter.

—Deborah Day

Deer

Like the deer, you are peaceful, gentle, and kind. You enjoy the little things.
You can easily share your serenity with others, calming them
and helping them to see the right path.

Key traits: peace, gentle caring, quiet, grace, sensitivity

In art and dream, may you proceed with abandon.
In life, may you proceed with balance and stealth.

—Patti Smith

Weasel

You use intellect and stealth to escape difficult situations or tasks.
You are able to form deep connections and relationships,
and are happiest amongst family and close friends.

Key traits: stealth, inquisitiveness, intellect

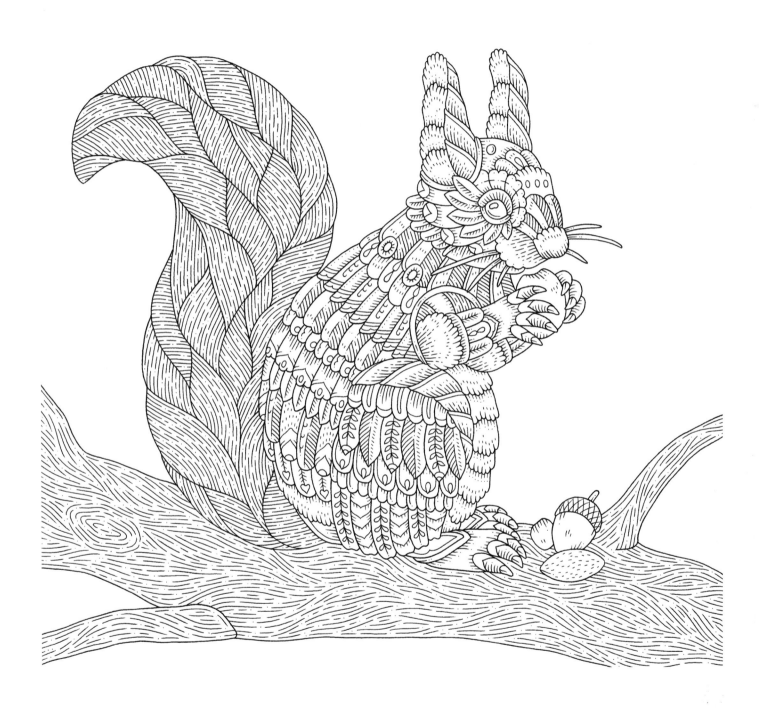

Passion is energy. Feel the power that comes from focusing on what excites you.

—Oprah Winfrey

Squirrel

You are a gatherer and collector, which makes you quite resourceful. You may have erratic tendencies that make you lose focus, but this also brings out a fun side of you that allows you and others to take life a little less seriously.

Key traits: resourcefulness, energy, fun